The Mystery of the Piltdown Skull

By Pat Perrin and Wim Coleman

COVER-TO-COVER BOOKS

Perfection Learning®

About the Authors

"History is full of wonderful stories—and exciting mysteries," say the authors of this series. "We love to find out about them and to write about them."

Pat Perrin and Wim Coleman are a married couple who often write books together. Over the years, they've held a lot of different jobs—teacher, editor, visual artist, waiter, pizza cook, and horse breeder and trainer. And for the past ten years or so, they've both been full-time writers.

Pat and Wim have written novels, plays, and nonfiction books for adults and young readers of all ages. They live and work in a beautiful Mexican town, San Miguel de Allende. They share their home with a five-year-old girl, Monserrat, and her mother, Guadalupe.

Editor: Judy Bates
Designers: Emily J. Greazel, Mark Hagenberg
Illustrator: Greg Hargreaves

Image Credits:

Associated Press: pp. 15, 39 (bottom), 40, 58; CORBIS: pp. 29, 34

Clipart.com: cover, pp. 3, 4, 9, 16, 17, 18, 19, 24, 25, 26, 27, 32, 35, 39 (top), 44, 52; Photos.com: pp. 10, 11, 30, 36, 43, 57

2 3 4 5 6 7 PP 15 14 13 12 11 10

PB ISBN-13: 978-0-7891-5991-5
PB ISBN-10: 0-7891-5991-0
RLB ISBN-13: 978-0-7569-1255-0
RLB ISBN-10: 0-7569-1255-5

PPI / 8 / 10

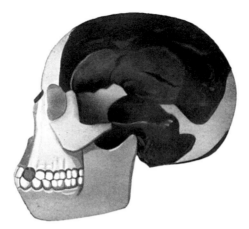

Table of Contents

Chapter 1 The Mystery Man . 4

Chapter 2 The Discoverers. 7

Chapter 3 Putting the Pieces Together. 21

Chapter 4 Suspicions!. 34

Chapter 5 Who Did It?. 46

Afterword . 57

Sources . 60

Glossary . 61

Index . 64

The Mystery Man

The place was southeastern England. The time was early in the 20th century. Pieces of a mysterious skull were found scattered in a bed of gravel.

Many years would go by before scientists realized what the skull really was. Even then, there would be many different ideas about how the skull got there. And there would be nearly endless arguments about who was behind the mystery.

Today, some things are known about the Piltdown mystery. But many questions still are not answered. This book includes known facts and also some imaginary scenes. For example, the following little story is made up—but it might have happened something like this . . .

Creating an Ancient Skull

The man sat down at a wooden table and carefully unwrapped a cloth bundle. He spread some things out on a table and looked them over. Then he laughed out loud. It was going to work!

These six pieces of human skull were just the right thickness. And the jawbone was exactly what he needed to finish the job.

Everyone would be fooled. It would be a great joke. And maybe it would show a few people that they weren't as smart as they thought they were.

Then the man frowned. There was still a problem with the jawbone. It didn't connect properly with the top part of the skull. Anybody who knew much about human **anatomy** would notice that right away.

But the problem wasn't hard to fix. Carefully, the man broke off a little knob of bone. It was the hinge that connected the jaw to the rest of the skull. He threw away the piece he had broken off.

There! That took care of that problem. Although this jaw could never have been part of this skull, now no one could see the truth.

He picked up the jawbone and looked at the two teeth still rooted in it. They were pointed teeth, like many animals have. He couldn't leave them that way. They had to be flat to look like human teeth.

The man picked up a file and went to work. He filed slowly and patiently until one tooth was flat.

Suddenly there was a sound outside his door. He heard light tapping. Then the knob turned. The door was opening! It must be someone who knew him well to just walk right in like that.

The man dropped the file. Quickly, he pulled the cloth over the bones.

No one must see them. Not yet. And certainly not here! he thought.

The man got up and went to the door to greet his visitor. It was a friend who had stopped by to see him. They chatted for a while about everyday things.

All the while, the man grew more impatient. He had important work to do.

After the visitor left, the man hurried back to the bones and teeth. He stayed at his task for many days after that. He worked on the skull whenever it was safe—whenever no one could see what he was doing.

Slowly and carefully, the man changed the pieces of skull. He flattened the other tooth and smoothed out the surfaces on both of them.

The man painted all the pieces to darken them. He soaked and stained them with a liquid containing iron. He made sure that any future chemical tests would show that the pieces were all the same age—very, very old.

Finally, the pieces of skull looked just the way he wanted. And all this time, he had managed to keep his work secret.

Chapter

The Discoverers

Starting about 1911, parts of a mystery began to turn up in southeastern England. Several people found pieces of a rare human skull. The discoverers included a lawyer, an expert from a museum, a priest, and a famous mystery writer.

A lot has been written about what these people found and how they found it. Some of the information is factual and some is a guess, such as the story of the mystery man. In this chapter are some stories about those discoverers—stories about what they might have said and done . . .

The Lawyer Finds the Bones

As he turned the piece of skull over in his hands, Charles Dawson had a wide smile on his face. This was exactly what he'd been looking for! In fact, he'd been hoping to find something like this ever since he was a schoolboy.

But why had this been left on the **rubble** heap to be hauled away or buried? The workmen usually saved any old bones they found. They knew that Dawson would be interested in them.

Over the past few years, the workmen had given him several nice old bones. But this one! This one was much too valuable to be tossed aside.

"Why didn't you save this one for me?" Dawson asked.

"That?" the workman asked. "Is that anything?"

"It might be more important than any we've found before."

"My, my," mumbled the workman. He rubbed his head with a dirty hand. Then he grinned and added, "We thought that one was a piece of coconut shell. It's so thick."

"It's thick, all right," Dawson said. "And that's what makes it important. Please keep a sharper eye out. Something like this could be . . . "

Dawson didn't finish the sentence. He wrapped the bone in a cloth and tucked it safely into his pack. He was going to enjoy showing this piece of skull to certain people.

They won't know what to make of it, he thought. They'll be astonished.

He looked over the gravel bed where the workmen were digging.

Maybe my good friends can even help me find some more pieces of this mystery, he thought.

Dawson chuckled at the idea.

It was about 1911 when Charles Dawson found part of a human skull. He was an **amateur paleontologist**. Even as a boy of 12, he'd often wandered across these hills looking for **fossils**. He had found them too.

This part of southeastern England was known as the Weald. It was an ancient forest that separated London from the English Channel. Here, **prehistoric** plants and insects had left their marks in clay. Over the ages, the marks had become fossils. Sometimes Dawson even found fossilized bones.

More exciting, dinosaurs had once roamed this land. As a teenager, Dawson spent a lot of time following footprints the

Dinosaur tracks

dinosaurs had left behind. He'd seen the birdlike tracks of iguanodons.

Even now, it was easy to imagine that the 6-ton monsters were still here. How the ground must have shaken as they stomped along, walking on thick hind legs!

Iguanodons were as tall as 16 feet. They were about 9½ feet long, including their heavy tail. They were herbivores, or plant eaters. But so are elephants. And nobody wants to mess with them in the wild!

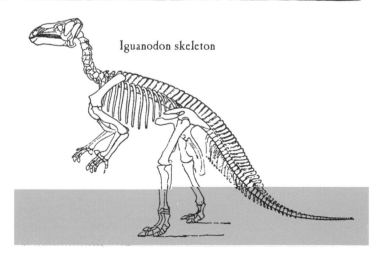

Iguanodon skeleton

9

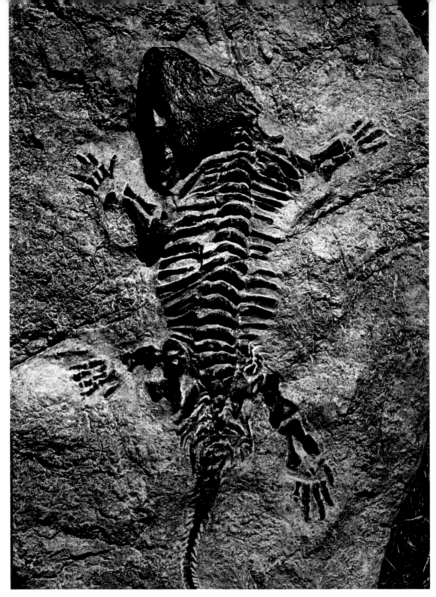

Reptile fossil

When Dawson had been a schoolboy, one of his neighbors was a well-known **geologist**. The boy had helped the geologist collect reptile fossils and record information about them. Then they donated their collection to the British Museum in London.

By the time Dawson was 20, the museum had made him an honorary collector. He didn't get paid for the job. But the title was quite an honor for a young man.

When he became a successful lawyer, Dawson didn't lose interest in fossils. He continued to collect them. He became very well known for his hobby.

Dawson's law office was in a nearby town. But he often came to the country. Part of his job was managing several large country houses. The houses and lands around them were estates.

Dawson was the man responsible for these estates. He did everything for the owners. He collected rents, checked on the servants, and made sure everything was in order.

He especially liked to wander along the tree-lined drive that led to the house called Barkham **Manor**.

Dawson still wondered what had lived here hundreds of thousands of years before—or perhaps millions of years ago. And he still kept looking for signs of whatever it had been.

Along that drive was a place where workmen dug for gravel. They sometimes found **ancient** bones. The gravel bed was in an area known as Piltdown Commons. So Dawson called the place where he had found the bone the Piltdown **site**.

Dawson was a middle-aged man who was well known in his community. He knew a lot about local history. But he had never lost interest in paleontology.

And now, Dawson had made the most exciting find of his whole life. This piece of skull might be the most important fossil ever found in England.

Could *he* be the one to find signs of an unknown **species**? Or even more exciting—an ancient **ancestor** of human beings?

The Keeper of Geology Gets a Note

Arthur Smith Woodward looked at the scribbled postcard one way and then another. It was hard to read. When he finally managed to make out a few words, he caught his breath sharply.

The note was from Charles Dawson. It said that fossils had been found in a very old gravel bed in the Piltdown area. And the card definitely said something about a "portion of a human skull."

"What on earth has the man found?" Woodward muttered.

When his assistants looked up, Woodward realized that he'd spoken aloud.

Be quiet! he told himself.

Woodward didn't want to talk about this to anyone else. Not yet.

Human skull bones found along with other fossils? That could be a very, very important discovery. And if it was, it should be made known to the world in just the right way.

Could Dawson possibly have found the remains of a prehistoric human being? Right here in England? Woodward wondered.

Arthur Smith Woodward was a scientist in the natural history section of the British Museum. Natural history is the study of nature and living things. It includes learning about how things begin and how they change over time.

Woodward's title was Keeper of Geology. He was in charge of **exhibits**, and he had looked at a lot of fossils.

Woodward and Charles Dawson had met years before. Since they were both interested in fossils, they had kept in touch.

In February of 1912, Woodward received a postcard from Dawson. That postcard drew Woodward straight into the mystery of the Piltdown skull.

The card said that Dawson had been looking over a very interesting area. He had found a gravel bed that he thought was probably the oldest in the Weald. Dawson added that he had not only found animal fossils but also part of a human skull.

Woodward knew that fossils of human ancestors had been found in Europe and Asia. But so far, none had been found in England. That's why he thought the postcard was so exciting.

Woodward wrote back to Dawson right away. But several months went by. No answer came.

Then in May, Dawson showed up in London. He brought Woodward three pieces of very thick, fossilized human skull.

Dawson said the first one had been found by workmen digging gravel to repair a road. After that, Dawson had found two more pieces in the same area.

In June, Woodward went to Piltdown to see where Dawson had found the bones.

The Priest Pitches In

"How wonderful!" Teilhard de Chardin said when Charles Dawson told him about the skull bones. "I've always been sure that human beings are improving in every way. Over a long period of time, humans change and grow. We improve **socially**."

"You don't think that ideas about **evolution** are against your religion?" asked Dawson. "Especially since you're a priest?"

"No I don't," Teilhard replied. "I think those ideas just give us clues as to *how* we've improved over time. And if you've really found an earlier kind of human being, that could help prove my point."

Right then and there, Teilhard de Chardin decided that he wanted to be part of this discovery team. Whenever he had time, the priest would dig along with the others.

Pierre Teilhard de Chardin was born in France. Even as a youngster, he was clearly very intelligent. By age 18, he had joined the Jesuit order of the Catholic Church. Jesuits valued study and learning. Some, such as Teilhard, were especially interested in science.

Teilhard had come to England to study at a Jesuit college near Barkham Manor. He loved being a priest. But Teilhard never gave up his interests in science, especially human evolution.

Like Dawson, Teilhard was an amateur paleontologist. The two men had met several years earlier when searching through rocks. Together, they had collected plant fossils and sent them to the British Museum.

When Arthur Woodward's train arrived, Teilhard went with
Dawson to meet him. Then the three men went to Piltdown
together by car. That's how a priest wound up digging in the
gravel beds near the road to Barkham Manor.

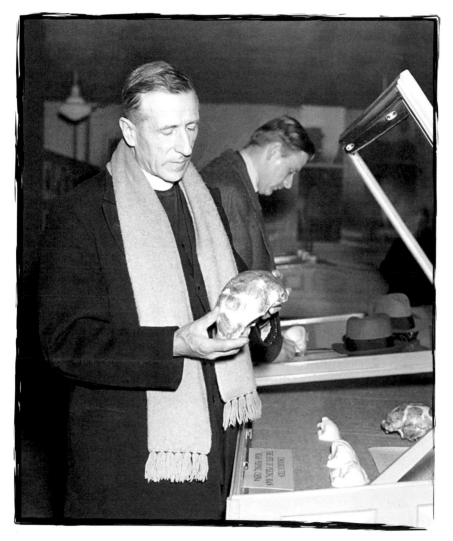

Teilhard de Chardin examining a prehistoric skull

The Piltdown Team

"On my!" exclaimed Woodward. "You've found a **mastodon's** tooth."

Grinning, Teilhard held out the tooth he had just dug out of the gravel. Woodward grabbed it happily.

The usually dignified expert from the British Museum could seem cold at times. But today, he was full of fire. He had all the enthusiasm of a boy.

"What a place this is!" said Teilhard.

"Right!" agreed Dawson. Then he added, "And don't forget the bone I dug out. It could be another part of the same skull I found earlier."

Woodward straightened his jacket and became more serious.

"I do believe," he said, "this site is worth further study."

"Perhaps a lot of further study," agreed Teilhard.

"I can work here on weekends," offered Woodward.

"So can I," said Dawson. "Maybe even some holidays."

Woodward nodded in agreement.

"And I'll come whenever I possibly can," said Teilhard.

Dawson laughed happily. "Who knows what we might find?" he added.

All during the summer of 1912, Dawson and Woodward spent weekends and holidays at the Piltdown site. They sorted through the rubble and dug in the gravel. And as he had promised, Teilhard sometimes worked with them.

Would they find anything valuable? It wasn't an easy job. The dark color of the old bones was a problem. The Piltdown gravel was dark too. It was hard to tell things apart.

But these three men knew what they were doing. They knew that the gravel and soil had to be handled very carefully.

First a workman broke the ground for them. Then the three discoverers took over. They carefully sifted every bit of the soil and gravel themselves.

It was slow, tiring work. But the men were searching for important **evidence**. They didn't want to miss even the tiniest bones.

At first, they found several pieces of skull. The new bones seemed to match the ones Dawson had found earlier. They also found different kinds of fossilized teeth—from a mastodon and a beaver.

Then—toward the end of June—something came flying out of the ground that astonished them all. It happened while Dawson was working at the bottom of the pit. There, the gravel hadn't been touched before.

Dawson was using a hammer with a pointed end, chopping into the gravel. His hammer hit something and sent it into the air. It was a jawbone. And it still had two teeth in it.

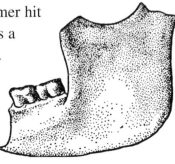

The jawbone was unlike any other human bone ever found. In fact, it looked very much like the jawbone of an ape. But those two teeth were definitely more human than apelike.

The Mystery Attracts an Author

"Why didn't you tell me about this right away?" asked Sir Arthur Conan Doyle. He pointed to the bones on the table. "Why, you must have known about these for some time. Had you already seen them when you and your wife came to lunch last year?"

"Not that early," Dawson replied. "But I do apologize. You see, we've been trying to keep it secret."

"Well, it's rather an open secret," said Doyle. "I've heard stories in several places. I wouldn't be surprised to see everything in the newspapers very soon."

"I hope not," the lawyer said. "But now I'm glad you've heard about the skull. And you're very kind to offer to drive us wherever we need to go. You're surely a busy man."

"Well, the truth is, I have a particular interest in your discoveries," Doyle said.

"I know that you've always been interested in dinosaur tracks and such," Dawson said.

"It's not just that. Haven't you been reading the *Strand Magazine* this summer? Haven't you seen my new stories?"

"I'm afraid not," the lawyer replied. "I've spent all my free time digging."

"Well, just wait till you hear what my new book is about . . ."

Sir Arthur Conan Doyle

When Dawson was digging at Piltdown, Sir Arthur Conan Doyle lived just seven or eight miles from the site. He often took long walks in that area. Once, he had found fossilized dinosaur footprints close to his home. In fact, Dawson and Woodward had come to see the footprints Doyle had found.

By 1912, Doyle was already well known for his stories about the great detective, Sherlock Holmes. But Holmes was never the author's favorite character. He was just the one who sold best.

Back in 1893, Doyle was tired of writing about Sherlock Holmes. In one book, the author even killed his famous character. But his readers were furious. The public demanded that Doyle bring back Sherlock Holmes. So Doyle did just that in another book.

Now Doyle had written a different kind of book, *The Lost World*. It was a science fiction tale of a forgotten land where prehistoric creatures still lived. That summer, *Strand Magazine* had run part of it in every issue.

Illustrations of Sherlock Holmes

In *The Lost World,* a small group of explorers reach a land where dinosaurs still live. But their greatest problem turns out to be near-human relatives. The character who is telling the story describes them this way.

> A face was gazing into mine—at the distance of only a foot or two. . . . It was a human face—or at least it was far more human than any monkey's that I have ever seen. It was long, whitish, and blotched with pimples, the nose flattened, and the lower jaw projecting, with a bristle of coarse whiskers round the chin. The eyes, which were under thick and heavy brows, were bestial and ferocious, and as it opened its mouth to snarl what sounded like a curse at me I observed that it had curved, sharp canine teeth.

No wonder Doyle was eager to see what had been found at the Piltdown site. He continued to visit there from time to time.

By then, the discoverers of the Piltdown bones were sure they had found something very important. Something that had been lost for a very long time. Something the modern world knew nothing about.

Dawson named the skull the "Piltdown Man" for the area where the pieces had been found.

The discoverers believed that early human beings had wandered over the Weald. These humans had lived there during the Stone Age. That was a time when people made tools and weapons from stones or bones.

The time before agriculture was invented was called the Old Stone Age. It had lasted from about 2,500,000 to about 10,000 years earlier. Dawson and Woodward thought that Piltdown Man might have lived in the earliest part of the Old Stone Age.

Perhaps more than 2 million years ago, prehistoric people had walked where the discoverers were walking now. Had the men found real proof of that?

chapter

Putting the Pieces Together

Everybody was eager to know more about the Piltdown Man. How long ago had he lived? How intelligent was he? Was he really an ancestor of today's human beings? And of course—what did he look like?

Over the years that followed, there would be lots of different opinions. It's easy to imagine those who found or saw the Piltdown skull asking the same questions . . .

Who Was the Piltdown Man?

"It's absolutely astounding," said Sir Arthur Conan Doyle. "Imagine! A man, perhaps a little like ourselves. But also partly an animal. And living in a total wilderness, having no idea what would come after him."

"It is hard to imagine, isn't it?" agreed Charles Dawson. "But because of him, we will learn things he never thought about. We'll have a clue about what came before us."

"So very, very long ago," added Father Teilhard de Chardin. "What did he look like? How did he live?"

"We should know more about what he looked like soon

enough," replied Arthur Smith Woodward. "I'm putting the skull bones together now. I think I can rebuild the skull. It will look very much like it originally did."

"Of course," Doyle reminded him, "we don't have a complete skull. A lot of the bones are missing."

"That's to be expected," said Dawson. "But we're very lucky. We did find a lot of the most important ones."

"I'll use what I know about how bones go together," said Woodward. "And I'll fill in the gaps with plaster."

"What about the other prehistoric skulls that have been found in Europe?" Teilhard asked. "Can you base your work on those?"

Woodward was silent for a moment. "Not from what I've seen so far," he finally said. "This skull seems to be quite different from the others."

"How exciting," murmured Doyle. "I can't wait to see it."

Dawson believed that the gravel bed where the bones had been found was very old. He thought the bones had probably been in the same place for a long time.

In some references, the Old Stone Age part of human history is called the **Paleolithic period**. Scientists use other words to talk about the history of the earth itself. Dawson thought the gravel bed and everything in it was from the **Pleistocene epoch**.

The Pleistocene epoch began more than 1.5 million years ago. The Old Stone Age began before the Pleistocene and lasted all the way through it.

How did Dawson and Woodward know how old the bones were? Well, they couldn't know for sure. In the early 20th century, there were no good tests to determine the age of fossils. The discoverers only had three things to go on.

- Geology gave them a good idea of how long the gravel bed had been in place.

- The bones were the same color as the gravel. That meant they probably had been there for a long time.

- Paleontologists knew that some of the other fossils found in the same gravel bed—mastodon teeth, for example—had to be very old. The animals they came from had been **extinct** for a long time.

During the Pleistocene, much of the earth was covered with ice. In fact, the Pleistocene is sometimes called the Great Ice Age.

An ice age is when giant **glaciers** cover much more of the planet than usual. Huge sheets of ice move across the frozen land. The ice **retreats** and returns, retreats and returns, again and again.

There have been several ice ages on Earth. Each of them lasted more than a million years.

In the Pleistocene ice age, sheets of ice covered one-fourth of Europe and Asia. The northern half of North America also was hidden beneath glaciers.

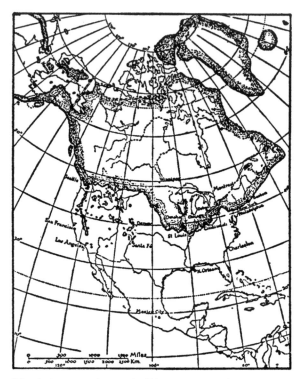

North America during the Pleistocene epoch

Mountains were covered with ice. Glaciers moved along the European Alps, the Asian Himalayas, and even the South American Andes. Mountains in Colorado and California were under ice.

The North American glacier also spread down onto the Great Plains. Imagine the great, thick sheet of ice popping, crackling, and sparkling in the daylight. That ice crept over a lot of what is now Kansas and Nebraska. New York City was iced over too.

During the Pleistocene, all of Great Britain was covered by a glacier. There was nothing but ice as far as could be seen.

Many **mammals** that lived in the Pleistocene are now extinct. For example, there were mammoths, mastodons, saber-toothed cats, and cave bears.

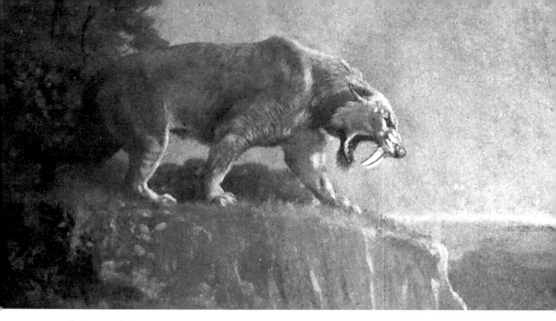

Saber-toothed cat

Most of these animals survived the ice age, but they died out afterward. Perhaps they disappeared because they couldn't compete with early human beings for food and space.

When the Piltdown bones were found, scientists could only guess who had lived so long ago. They didn't know much about such ancient beings.

Stone tools had been found in England and on the European continent. The bones of extinct animals were often found in the same places.

| Stone ax head | Stone arrowhead | Stone hand ax |

So **anthropologists** knew that somebody had hunted with sharp knives and spears. Somebody had sat near a fire, chipping away at bones or stones to make them just the right shape. And somebody had used the weapons to hunt large, fierce animals.

But was that somebody human?

Very old bones that *looked* human had been found in England and other European countries. Humanlike skulls had also been found in Germany and other places. Most of the skulls had slanted foreheads and not much space for brains.

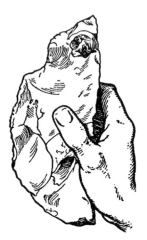

Chopping tool for making other tools and weapons

The lives of these early people must have been short, simple, and hard. But they were already making tools and weapons. And those tools gave them the power to change things around them. Even so, they could only change things very slowly.

Today, scientists believe that more than one kind of human being lived long ago. They all walked upright, made and used tools, and lived in communities. Some of those humans died out. Others, probably originally from Africa, became the ancestors of all humans that live today.

Dawson's Dawn Man Goes Public

"Have you seen the newspaper?" asked Dawson. "It's a wonderful story."

"Yes," agreed Woodward. "And the story agrees with everything we've said about the skull."

During the summer of 1912, other people joined the Piltdown digging team. That fall, someone leaked the story to a newspaper. The *Manchester Guardian* published an article about the bones on November 21, 1912.

The *Guardian* said, "There seems to be no doubt whatever of its **genuineness**." The paper suggested that this might be the oldest remains of a human being "yet discovered on the planet."

Other newspapers picked up the story. A lot of excitement built up about the Piltdown skull.

Soon, Woodward finished rebuilding the skull. As he had expected, it was different from any other ancient skull yet discovered. For one thing, the forehead wasn't completely flat—this skull had a little more room for a brain.

Woodward decided that human ancestors must have split into two different types. He believed that the Piltdown Man was the true ancestor of modern humans.

On December 18, 1912, Dawson and Woodward presented the skull and their ideas about it. They spoke before a group of important scientists—the Geological Society of London.

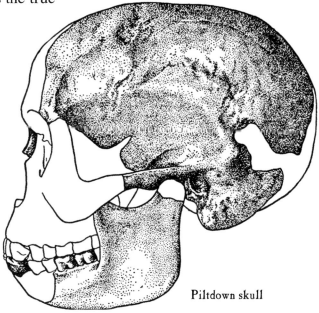

Piltdown skull

Dawson and Woodward suggested a scientific name for their prehistoric human. They said it should be called *Eoanthropus dawsoni*. But the newspaper stories usually called it "Dawson's Dawn Man."

Woodward wanted more people to see what the Piltdown skull looked like. He had a company make a model of it and put copies up for sale.

Other Experts Have Their Say

"This can't be right," muttered Arthur Keith. He stared at the model of the Piltdown skull. "Woodward has made a mistake. This looks too much like an ape."

Keith had been one of the first to buy a model of the skull. But he was disappointed. The Piltdown Man didn't look at all the way he had expected.

I can do a better job with these bones, Keith thought. And I will!

The Piltdown skull started a lot of arguments. Some people insisted that the jawbone and the skull bones didn't go together at all. They said that the skull pieces belonged to a human and the jawbone belonged to an ape.

They said the bones could have been carried there from separate places. Perhaps they were washed there by water. Or maybe animals had dropped them in that gravel bed.

But Woodward said those people had to be mistaken. The bones had been found very close to one another. Therefore, they must belong together.

In fact, the team had found some of the exact parts they needed for one skull. How could those bones be from different creatures?

Arthur Keith was a well-known expert in anatomy. He had an important job at the museum of the Royal College of Surgeons. His responsibilities were a lot like Woodward's at the British Museum.

Keith was one of the first to buy a plaster copy of the Piltdown skull. But it didn't match his own **theory** about what early man should look like.

Actual cast made from the original Piltdown skull

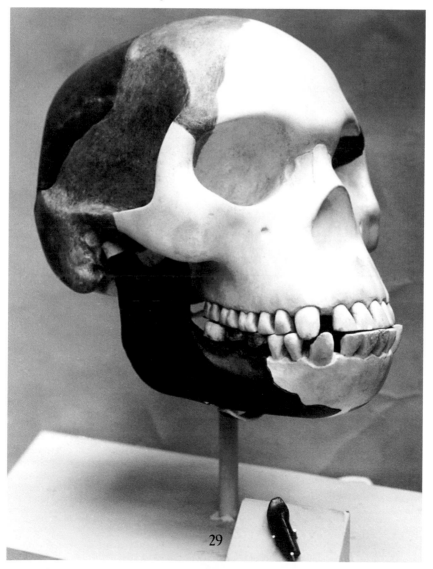

He thought that the skull must be even older than Woodward and Dawson said. Keith was sure that it was older than any of the skulls found in Europe.

Piltdown Man had lived in an earlier time, Keith argued. And not only that, Piltdown Man had been smarter than any other early humans.

Keith agreed that probably two types of human beings lived in the Pleistocene epoch. And he was sure that the Piltdown Man was the superior of the two.

Keith's theory meant that more intelligent, more advanced humans had lived in England before anywhere else. Lots of English people of that time liked his ideas. It was important to them that their ancestors be smart—and be English!

Using copies of the Piltdown bones, Keith rebuilt the skull his own way. It didn't look much like the one Woodward had made.

On Woodward's skull, the teeth slanted forward and some were pointed. Keith was sure the teeth would be small and flat. He also gave his man more of a chin.

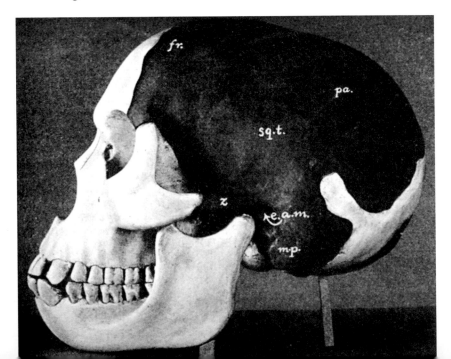

The most important difference was the forehead. The Piltdown skull that Arthur Keith put together had a high forehead. It had a lot of room for a brain.

Keith thought that Piltdown man had been completely human. He insisted that the creature's scientific name should be *Homo piltdownensis.*

Woodward and Keith got together and talked the whole thing over. But they still didn't agree. Other experts took one side or the other. Or they presented their own ideas. The arguments went on and on. And they became louder and louder!

More Bones to Tell the Story

"Father Teilhard, you've been digging too hard," Arthur Woodward insisted. "You look exhausted."

"Yes," agreed Charles Dawson. "Leave the hard labor to us for a while."

Teilhard refused to quit. So Dawson put him to work searching through some gravel that had been washed by the rain.

A few minutes later, Teilhard called out to them. "I've found a tooth!"

"Are you sure?" Woodward asked. "We've seen some stones that *look* a lot like teeth. Near where you are."

"I'm not wrong," called Teilhard. "Come and look at this."

The two other men hurried over to see.

"You're right," said Woodward. "It *is* one of the teeth. And look, it's . . . " Woodward's voice trailed off.

"It's just like you thought it would be," said Dawson. "It's like the ones you put in your skull. You were right all along."

The three men spent the rest of the afternoon searching through the loose gravel. But they didn't find anything else.

In the summer of 1913, Dawson and Woodward had returned to Piltdown. They were again digging in the gravel. They wanted to prove that Woodward was right about how the jaw looked. So they were especially looking for teeth.

Teilhard joined them. That's when the priest found that all-important tooth. Woodward was delighted. He planned to present the tooth to a group of scientists in September.

But again, the story was leaked to the press. It was announced in newspapers before the scientists met.

The tooth seemed to show that Woodward was right about how the Piltdown Man looked. But it didn't end the arguments. Experts of all kinds still quarreled about the ancient skull.

An artist's rendering of how the Piltdown man might have looked

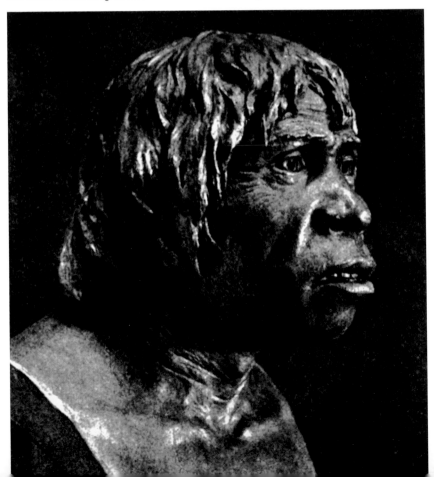

Soon, Woodward and Dawson went back to their digging. Now they were often watched by others as they searched through the gravel. The Piltdown site had become a popular place to visit. Some of the watchers even helped dig.

In the summer of 1914, a workman turned up two pieces of a prehistoric tool. It had been carved out of bone. But after that, no one found anything at all.

They dug new ditches in the gravel. They even started searching the nearby fields. But still—nothing.

Months later, in January of 1915, Dawson finally came across some fossilized bones. He'd been digging not far from where they had found the first bones.

The bones Dawson found were from a human nose. Dawson had found part of another prehistoric skull!

Dawson called the new site Piltdown II. Later that year, he found several more pieces of the second skull. And he found a human tooth.

Dawson told Woodward that a friend had been working with him at the new site. He showed Woodward a rhinoceros tooth the friend had found. That fossil helped them guess how old the human bones might be.

The new evidence was just what Dawson and Woodward needed. This second skull was similar to the first one. They said that finding two fossil skulls in the same general area couldn't be an accident. Some kind of ancient humans must have lived there.

The new bones helped convince many people that they were right.

Unfortunately, Dawson didn't get to enjoy their victory. He was already showing signs of illness. He was **anemic**. Nothing he or his doctor did seemed to help. In August of 1916, Charles Dawson died.

Suspicions!

The Piltdown bones were put on display in the Natural History section of the British Museum. People from many different places came to see them. It seems that everybody had an opinion as to what they were . . .

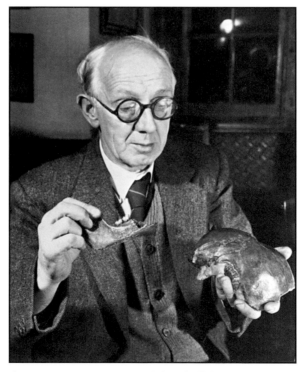

A professor examining a model of the Piltdown skull

Signs of Evolution

"The jaw is from an ape," said a man who was looking at the Piltdown skull. "Anybody can see that. Only the top part of the skull is from a human being."

The scientist next to him didn't agree. "All those bones belonged to the same skull," he replied sharply. "They were found in the same place. The skull is from our very own ancestor."

"Do you think our ancestors were half ape and half human?" the first man exclaimed. He sounded a little angry.

"Mr. Darwin found good reasons to think so," said the scientist. "And I believe that these skulls will help prove Mr. Darwin's theory."

In the last half of the 19th century, Charles Darwin had published his theories on evolution. Darwin was a **naturalist**. He spent a lot of time looking at birds and animals. He made notes about the differences in them.

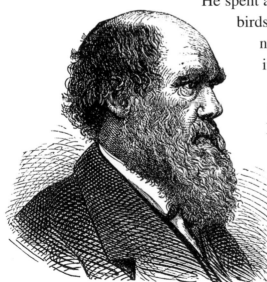

Darwin did a lot of his work in the Galapagos Islands. These 13 islands are in the Pacific Ocean near the coast of South America. They are part of Ecuador.

Charles Darwin

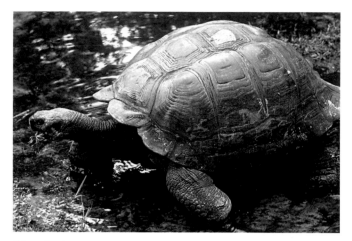

Giant land tortoise

The Galapagos are famous for their unusual animal life. Giant land tortoises live there. Some Galapagos iguanas—a type of lizard—are the only iguanas that swim in the ocean. And in the Galapagos, birds called cormorants don't fly. But they are great divers and swimmers. They can catch fish deep underwater.

After observing animals for a long time, Darwin developed some theories about them. For one thing, he thought that all living species have evolved from more **primitive** creatures. That's the way nature works, he had said.

That meant that human beings had also evolved from more primitive creatures. People had a lot of different opinions on that idea. Today, the modern science of **genetics** is explaining more about how evolution happens.

By the time the Piltdown skull was found, the general idea of evolution had been accepted by most scientists. They were looking for fossils to show how humans had evolved. So the scientists were looking for the **missing link**.

A link is something that connects other things together, like one piece of a chain. A missing link is a gap in the chain. There are gaps in what scientists know about the history of living creatures. The creature that would fill a gap is often called a *missing link*.

The fossils of plants, insects, animals, and people were left on Earth over millions of years. As the earth changed, the fossils were scattered. When they are found, it is sometimes just by chance.

Because of the great length of time that has passed, scientists don't have an example of everything that ever lived. There are a lot of gaps to be filled—a lot of missing links.

There's more than one missing link in the history of ancient humans. But the term usually means a creature that links humans to apelike ancestors.

When the Piltdown skull was found, scientists were on the lookout for missing links. Finding any new human ancestor could help prove that Darwin was right. And it could help people learn more about their own past.

In 1856, the bones of ancient humans called Neanderthals were found in Germany. After that, a lot of people started searching for other human fossils.

Other bits and pieces turned up in the last half of the 19th century. Some of them did seem to link humans to ape ancestors. But scientists still wanted a better example.

Then the Piltdown skull was found early in the 20th century. It seemed to be exactly what scientists had been looking for.

Piltdown Man Doesn't Fit In

"See what a big brain Piltdown Man had," said the British scientist.

"The skull is supposed to be very old," said an American woman. "That means that prehistoric humans must have had big brains a very long time ago."

"At least the English ones did," said the scientist.

"Only the English?" she asked, with a laugh.

"That's right," the scientist answered. "That big brain first appeared right here in England."

"Unfortunately," said the woman, "Piltdown Man doesn't fit in very well with fossils from other lands. The head is a completely different shape from any other skull found anywhere."

As the years went by, other prehistoric human fossils were found. And some people began to see real problems with the Piltdown skull. It was just too different from the others.

All the human skulls had some things in common—such as sloping foreheads and not a lot of space for brains. All, that is, except the Piltdown skull. After a while, it seemed that the theory of human evolution only made sense if Piltdown Man *wasn't* part of it.

Beginning in 1927, the fossilized bones of many ancient humans were found in a cave in northern China. Scientists helped date these early humans. That cave had been their home between 460,000 and 230,000 years ago.

One prehistoric Chinese human skull was named Peking Man. (Now it's usually called Beijing Man.) Scientists could tell that Peking Man and Piltdown Man would have looked very different.

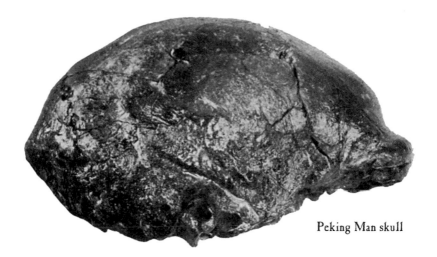

Peking Man skull

Many bones and skulls were found in that Chinese cave.
But only a few pieces were found in Piltdown. So, the evidence
was stronger for Peking Man. He was more likely to be a true
human ancestor.

Soon more remains of prehistoric humans were found in
Africa. Louis S. B. Leakey, a British anthropologist and
paleontologist, worked in Africa with his wife, Mary. In 1932,
the Leakeys found part of a fossilized human jaw.

Louis S. B. Leakey
holding the
prehistoric jawbone
that he and his wife
found in Africa

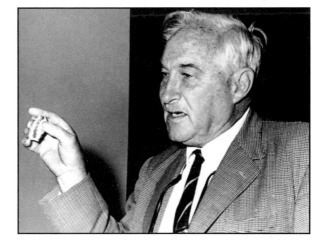

Mary Leakey

Unlike the one found at Piltdown, the African jaw didn't look like an ape's. The Leakeys felt that the prehistoric African was the true ancestor of modern humans.

Other prehistoric bones were found in other places around the world. Those who believed in Piltdown Man kept trying to fit the skull in with the others.

Arthur Keith still said the Piltdown skull was earlier. But Piltdown Man began to lose some of his fans.

Then Kenneth Page Oakley tried a different test on the Piltdown skull. He was a **paleoanthropologist** who worked at the British Museum.

Oakley knew that old rocks and bones contained the chemical fluorine. In fact, the older the rocks were, the more fluorine they contained.

By 1948, fluorine tests had been used on some other British fossils, as well as some in Africa. Although the test itself was still being evaluated, it seemed to work.

During the summer of 1949, Oakley used fluorine test on the two Piltdown skulls. He said the test showed that the two skulls were the same age. That helped show that they were from the same kind of human being.

But the tests also showed that the skulls couldn't be as old as Dawson and Woodward had thought. Oakley still believed that the skull was from a prehistoric human. But he felt it was

one from a much later time. He thought the Piltdown people might have lived about the middle of the Stone Age.

But there was a problem with that idea—the apelike jaw. In that part of the Stone Age, humans should have had human jaws. Some people suggested that maybe Piltdown was a throwback. That meant that a whole group of creatures had stayed the same while the rest of the world evolved. Or perhaps it had even gone backward in evolution.

It sounded like a book by Arthur Conan Doyle. In *The Lost World,* apelike people and more modern people lived at the same time. Of course, dinosaurs also still lived in *The Lost World.* And, in case you've forgotten, dinosaurs were extinct for millions of years before even apelike people appeared.

But had there once been partly human throwbacks in the Weald?

Fake!

"Why didn't the British Museum continue digging at the Piltdown II site?" asked Joseph S. Weiner. "If they had, they might have learned more about the mysterious skull."

"Nobody knows exactly where Piltdown II is," replied a British scientist.

"Why not?" exclaimed Weiner.

"Dawson didn't make a record of it before he died," the man replied. "He just sent Woodward a postcard. No map. No notes. So nobody has been able to figure out the location."

"Wasn't someone else working there too?" Weiner asked. "Didn't someone else find a fossilized animal tooth?"

"Dawson said so. But nobody knows who his friend was."

Weiner was really surprised to hear that. After all, the bones found at Piltdown II were very important. They had helped convince many people that the first skull and jaw went together.

Later, Weiner couldn't get the problem off his mind. He thought about the possibilities.

Was Piltdown Man really a man-ape? A missing link?

Or was Piltdown Man an accident? Did the skull and the jaw end up near each other just by chance?

Was there any way to prove either theory?

Weiner thought about it for a long time. Suddenly he gasped.

There's another possibility! he realized. Now that I think of it, that seems the most likely to be true.

In 1953, paleontologists from all over the world held a meeting in London. They were there to discuss "Early Man in Africa." By that time, many human fossils had been found on the African continent.

The Piltdown bones were still on display in the museum. Most of the scientists at the meeting went to take a look at them.

However, the Piltdown skull was still a mystery. It didn't fit in with other human fossils. That's what started Joseph S. Weiner thinking about the problem.

Weiner had been born in South Africa. He'd worked on sites in Africa where important human fossils were found. Now he was an anthropologist at Oxford University in England.

When Weiner was at the meeting, he looked closely at a copy of the jawbone. He was sure that his idea was right. Even on the copy, it looked to him like the teeth had been worked on.

But Weiner had to be sure. He needed to look closely at the original bones. But for that, he would have to get permission from Kenneth Page Oakley at the British Museum.

Weiner thought things over for a week. Then he talked them over with his superior at Oxford, Wilfred Le Gros Clark. Finally, Clark made a phone call to Oakley. He told Oakley what he and Weiner suspected.

Oakley was shocked. Many people had problems with Piltdown Man. But no one thought that somebody had put the odd bones together on purpose. No one had ever suggested that the Piltdown skull was a fake!

Oakley agreed that they should all look at the original bones again. But he said they had to keep their work secret until they had an answer.

Weiner, Oakley, and Clark got together to look at the real Piltdown bones. They looked at the teeth with a **microscope.** The teeth definitely had scratch marks on them! They seemed to have been polished with something slightly rough.

The scientists also saw that the teeth weren't worn down in a normal way.

They decided to do the fluorine test again. This time, they found a difference in the skull and the jawbone. The skull was much older than the jaw and teeth!

Weiner suspected that all of the Piltdown bones had been stained to make them darker. That could make them seem the same age.

The scientists studied the teeth with a microscope.

More tests showed that Weiner was right. Somebody *had* stained the bones.

Someone *had* **forged** the skull.

The Piltdown Man was a fake! A trick played on some of the best scientists of the time!

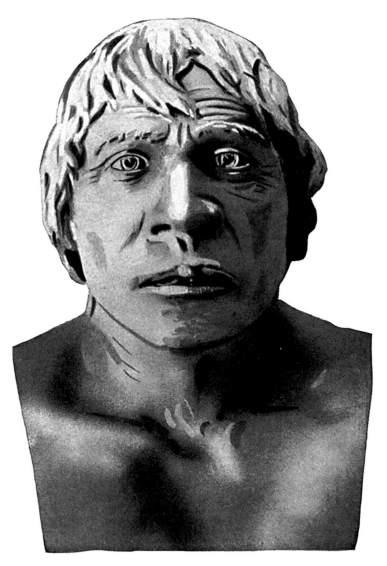

The Piltdown Man was determined to be a fake!

The Piltdown skull fooled the world for 40 years. In all that time, why hadn't anyone realized that it was a fake? On the Piltdown Man home page, Richard Harter suggests reasons like these.

- **The people who found the bones were well known.**
 Dawson, Woodward, and Teilhard were all respected men. No one would suspect any of them of faking the bones. However, none of them was really an expert on fossils.

- **There were not many good scientific tests.**
 Today, scientists have many ways of telling how old fossils are. Most of those methods didn't exist when the Piltdown skull was found.

- **The forger was skillful.**
 Whoever made the fake knew about the few prehistoric human bones that had been found. He knew what an ancient human skull might look like. And he knew what kinds of tests could be made on the bones.

- **The skull fit some people's favorite theories.**
 At the time it was found, the Piltdown skull fit popular theories. Some scientists believed that humans had developed a big brain very long ago. They liked the idea that these big brains had appeared in England rather than Africa. They expected intelligent early humans to be the ancestors of the white race.

 After years passed and more skulls were found, new theories were formed. But Piltdown Man didn't fit the new theories very well.

- **Luck**
 Mistakes were made by the people who first looked at the skull. For example, they didn't look at the teeth under a microscope. If they had, they would have seen the scratch marks. Some other tests also weren't done very well.

chapter 5

Who Did It?

So the mystery skull was a fake! Maybe some other kind of prehistoric humans had once lived on the Weald—but not Piltdown Man.

The top part of the skull was old, but not nearly old enough to be prehistoric. And it hadn't originally come from Piltdown. And the ape jaw wasn't even very old.

Some of the other things found in the dark gravel were real fossils and some were fakes. But all of them had been stained. They'd been brought to Piltdown from other places.

Someone had planted all the parts of the skull in the gravel pit. Someone had waited for the skull to be found. Or pretended to find parts of it, and then showed it to others.

But who had put the "fossils" there? And why? Those are the missing links in the investigation.

At one time or another, a lot of different people were accused of the forgery. A friend of Dawson's was suspected. He was a jewelry maker, and he could have faked the bones. An official of a small museum was suspected because he had a grudge against Dawson.

A zoologist at the British Museum was suspected because he had experimented with staining fossils. He was fond of practical jokes, and he didn't much like Woodward.

Several other paleontologists were suspected. But there was really no evidence against any of them.

The most likely suspects were those who had spent the most time at Piltdown—Charles Dawson, Arthur Woodward, Teilhard de Chardin, and Sir Arthur Conan Doyle.

Different people checked on the suspects. What did they learn?

Imagine listening to some imaginary characters. It's now sometime in the 1950s. Two newspaper reporters, Anna and Roy, are talking over each suspect . . .

Charles Dawson

"Of course," said Anna, "everyone would naturally suspect Charles Dawson."

"Dawson found both Piltdown sites," said Roy. "He brought the other people there."

"But Dawson didn't find the first bones himself," Anna reminded him. "They were found by a workman."

"That's true," Roy replied. "But Dawson was there. And Dawson could have put the fossils in the gravel. He'd know the workman was sure to dig them up."

"And Dawson was there every time anything was found," Anna said, nodding. "He said a friend of his found some bones at Piltdown II, wherever that is. But nobody knows who that friend was."

"Or even if that friend really existed," said Roy. He added, "No one knows if Piltdown II really existed."

"The big question is," Anna replied, "would Dawson have done it?"

"Maybe he would," answered Roy. "I've heard some old stories about Dawson. They say he'd been up to no good several times before."

"I mean, would he be stupid enough to pull a trick like that?" Anna wondered. "Dawson had to know that he would be the first suspect."

"Well, Joseph Wiener has spent a lot of time looking into everything," said Roy. "Maybe he'll find the truth."

Joseph S. Weiner had proven that the skull was a forgery. Now he set out to find the forger.

Like any good detective, Weiner asked a lot of questions. He talked to everybody he could find who had anything to do with Piltdown.

He started near where the skull was found. Weiner learned that a man named Harry Morris had lived in that area. And Morris had been suspicious of the skull for a long time—and of Dawson too.

Harry Morris had collected a lot of fossils. Morris had died, but his collection was still in a large cabinet in his widow's home. She let Weiner look through it.

In a drawer marked "Piltdown," Weiner found some stone tools and notes Morris has written. The tools were brown like everything that came from the Piltdown site. One note said, "Stained by C. Dawson with the intent to defraud."

Tests showed that Morris was right. The pieces in the drawer had all been stained. They might be old, but they hadn't originally come from Piltdown.

After that, Weiner checked on the bone tool that had been found at Piltdown. Tests showed that it had been carved with a metal blade—something that hadn't even existed in the Stone Age. The bone tool was a fake too!

Arthur Keith learned that Dawson might have been involved in other shady deals. He was accused of cheating a group of people out of a fine building.

Dawson might even have been guilty of **plagiarism**. He had written a two-volume *History of Hastings Castle*. Some considered it an excellent history of a local landmark. Others said that it had been copied from an older book.

All the stories about Dawson might or might not have been true. But it *was* true that Dawson had collected fossils and donated them to the British Museum. Those weren't fakes.

Weiner realized that his evidence against Dawson was weak. He thought that maybe Dawson had wanted to play a joke. And then the joke had gotten out of hand. Maybe, after all the publicity, Dawson couldn't admit that the Piltdown skull was a fake.

And it was still possible that Dawson was fooled, like everybody else.

After a while, many people came to believe that Dawson must be part of the puzzle. But if he *was* the forger, did he work alone? Or did Dawson work with somebody else?

Some people suspected Arthur Keith, the expert in anatomy. Over the years, Keith had argued with Woodward about how Piltdown Man had looked.

Had Keith worked with Dawson? Or had Keith faked the fossils alone, to embarrass Dawson? Both seemed possible. But no one could prove that Keith had been involved at all.

Arthur Smith Woodward

"Well," said Anna, "no one ever seems to suspect Arthur Woodward."

"He's such a serious man," agreed Roy. "Even a little stuffy. It's hard to imagine Woodward faking anything."

"That's right," Anna agreed. "There's no reason to think he ever did anything wrong."

"It's true that a workman found the first bones at Piltdown," said Roy. "Anyone could have put them there."

"And it's true that Woodward's records were sloppy," said Anna. "He didn't ask Dawson enough questions. Or he didn't write down the information when he should have."

"I think that, sooner or later, someone is going to suspect Woodward," said Roy.

For a long time, no one accused Arthur Smith Woodward. The geologist for the British Museum was too highly respected. And there were no stories about forgery or plagiarism or any other wrongdoing in his background.

But Weiner thought that some of the work at Piltdown hadn't been done very carefully. And he wondered why Woodward hadn't insisted on knowing the exact location of Piltdown II.

Others pointed out that Woodward was ambitious. He hoped to someday become head of the British Museum. And the Piltdown skull helped Woodward's career. It made him famous.

Did ambition push Woodward into faking the skull? Or helping Dawson with the forgery? Or at least helping Dawson have the fake accepted as real?

But that would have been dangerous. If Woodward had been part of the plot and had been caught, his career would have been over.

In the mid-1940s, Woodward was past 80 and blind. He had retired from the museum. He dictated his last book, *The Earliest Englishman,* which was published in 1948. Woodward still seemed to believe in Piltdown Man.

Pierre Teilhard de Chardin

"What about the priest?" asked Roy.

"Father Teilhard de Chardin?" asked Anna. "But he's a popular speaker and writer. Everyone thinks he's very wise. How could he be guilty of such a thing?"

"He was young when the Piltdown skull was found," said Roy. "He could have been more playful then."

"It's true that Teilhard was an amateur paleontologist, just like Dawson," said Anna.

"He never gave up his interest in science," added Roy. "He's always wanted to prove that humans evolved."

"I'm sure that someone will ask Teilhard what he knows about it," said Anna.

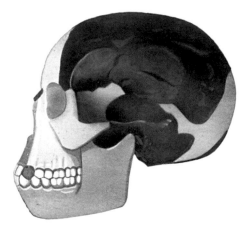

Kenneth Oakley was the one who had made the first fluorine test on the Piltdown skull. He was very interested when later, better tests showed that the skull was a fake. He wanted to help find out who the forger was.

In 1953, Oakley wrote to Teilhard de Chardin. The priest was then in New York. Oakley's letter asked the priest what he thought about the forgery.

Teilhard wrote back. He said that of course no one would suspect Woodward. But Teilhard didn't think Dawson had done it either. He said that Dawson wouldn't deceive his friends, especially not Woodward.

Oakley and Weiner continued to write to Teilhard. After a while, the priest seemed to get impatient with their questions.

They realized that Teilhard might be feeling rather foolish. The priest had found some of the fossils himself. He had believed in the Piltdown skull. He was famous now and probably didn't want to look stupid.

But Teilhard had been there when the important fossils were found. He even admitted he'd visited the site of Piltdown II. Weiner and Oakley became suspicious of the priest.

The next time Teilhard visited England, Weiner and Oakley met with him. It was 1954. By this time Teilhard didn't want to talk about Piltdown at all. He only said that "it was a souvenir of my youth and so to me it was rather sad."

Teilhard said that he had a hard time remembering exactly what happened. He couldn't recall where the Piltdown II site had been.

So Oakley and Weiner never found out much about the Piltdown story from Teilhard. The priest returned to New York. In 1955, he had a heart attack and died.

In 1982, Stephen J. Gould published a book called *The Panda's Thumb*. Gould was a paleontologist at Harvard University. In the book is an essay called "Piltdown Revisited."

Gould said that, most likely, Dawson faked the fossils alone. But Gould was convinced that Teilhard was somehow involved. Perhaps, he said, Teilhard was trying to make English paleontologists look foolish.

Gould also thought that Piltdown could have been a joke that went too far. He pointed out that Teilhard was once a young student, fun-loving and full of mischief.

> I can easily imagine Dawson and Teilhard, over long hours in field and pub, hatching a plot for different reasons: Dawson to expose the gullibility of pompous professionals; Teilhard to rub English noses once again with the taunt that their nation had no legitimate human fossils, while France reveled in a superabundance that made her the queen of anthropology. Perhaps they worked together, never expecting that the leading lights of English science would fasten upon Piltdown with such gusto. Perhaps they expected to come clean but could not.

Arthur Conan Doyle

"Some people say the mystery writer faked the skull," said Roy.

"You mean Arthur Conan Doyle?" asked Anna.

"That's right," replied Roy. "Doyle had the opportunity. He lived very near Piltdown. He took long walks all over that part of the countryside."

"And Doyle was smart enough to pull it off," said Anna. "But why would he do it?"

"He was interested in prehistoric creatures," said Roy. "He even wrote a book about them. And he wrote another book called Human Origins. That one was never published."

"That might be why Doyle was interested in the skull," said Anna. "That doesn't mean he faked it."

"Doyle didn't like scientists," said Roy. "He was angry with them for saying that he hadn't really contacted his dead son through a **spiritualist**."

"Doyle would know how to put the skull together," admitted Anna. "Because he was a doctor. But that doesn't prove anything."

"Maybe we need the help of Doyle's most famous character," said Anna. "We need the cold, clear thinking of Sherlock Holmes."

As was stated before, Sherlock Holmes was never Arthur Conan Doyle's favorite character. The author didn't share his detective's way of figuring things out.

Doyle believed in spirits. After his son died, he tried to reach the lost child through a spiritualist.

Doyle's favorite spiritualist was named Henry Slade. But Slade was proven to be a fake. Because of that, some people thought Doyle might be angry with scientists in general. Maybe he had faked the skull to make scientists look foolish.

The famous author died in 1930. Since then, several people have suspected him of the forgery. Some have written magazine articles pointing out that Doyle *could* have done it. He knew how, and he lived nearby. But no one had real proof.

In 1996, an article in *Pacific Discovery* magazine also accused Doyle. "The Case of the Missing Link" was written by Robert B. Anderson of the American Museum of Natural History.

Anderson said that Doyle had left clues about the forgery in *The Lost World.* For example, in Doyle's book the explorers use torches made of araucaria wood. Another name for the tree that the wood comes from is "monkey puzzle." And guess what kind of trees grows along the road to Barkham Manor—monkey puzzle trees!

In the book, the explorers are given a map. But it's really a puzzle they have to solve. And one of them says that it could be a trick played by a "primitive practical joker." Anderson thinks that Doyle left such clues to see if anyone would figure them out.

Some people think that Doyle faked the Piltdown skull just to prove he could do it. If that's true, maybe Doyle *was* a little bit like Sherlock Holmes after all. Maybe he felt that he was smarter than most of the rest of the world.

Solutions?

"I guess that most people think that Dawson faked the skull all by himself," said Anna.

"Do you think that solves the mystery?" asked Roy.

"No," said Anna. "I think that other people will have different opinions about the Piltdown mystery."

"They're likely to argue over this for a long time," agreed Roy.

Weiner's book *The Piltdown Forgery* was published in 1955. He said that Dawson alone was the forger. Weiner felt that he had settled the question.

But Anna and Roy were right. Over the years, other people did still have other opinions. In 1999, a new book was published that agreed with Weiner.

The author, John Evangelist Walsh, has written many books on science and history. In *Unraveling Piltdown: The Science Fraud of the Century and Its Solution,* Walsh carefully goes over all the evidence against each suspect. He also decides that Dawson did it.

Some people are content with the way Walsh solved the mystery of the Piltdown skull. Of course, other people aren't.

What about you? How would you solve the mystery of the Piltdown skull? Who do you think forged the fossils? And why?

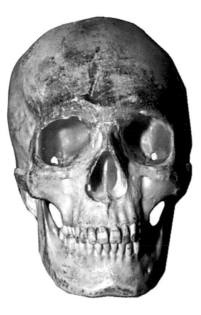

Afterword

Mysterious Fossils Today

Paleontologists and other scientists still puzzle over prehistoric bones and stones. But their questions aren't so much about the age of the fossils. Now there are many different ways to test fossils. It would be much more difficult to fake one today than it was 100 years ago.

Today's questions are about what kind of creature the fossils came from. And where that creature fits into the record left by fossils. Those who study human fossils are still looking for—and finding—bones from missing links.

Anthropologist Donald Johanson is well known for his studies of human origins. In 1974, Johanson found a fossilized humanlike skeleton in Ethiopia. He named the skeleton "Lucy." Later, he found other bones of the same kind of creature.

Johanson believed that Lucy belonged to a early human species that lived about 3.5 million years ago. He said that Lucy and her kind were a missing link in human evolution.

In Chapter 4, the British anthropologist Louis Leakey was mentioned. He and his wife, Mary, and their son, Richard, found many important human fossils. Some of them were 3 million years old, or more.

The Leakeys also studied ancient human campsites. They learned a lot about how Stone Age people lived. The Leakeys learned to make stone tools themselves. And they figured out how prehistoric people got their food.

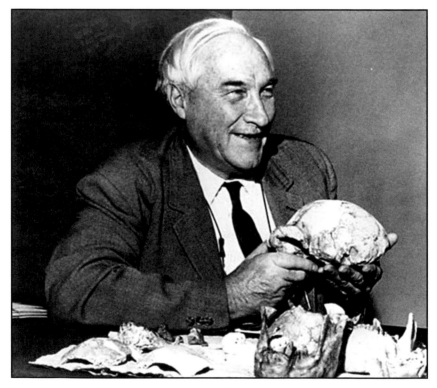

Louis Leakey holding an early primate fossil

Louis Leakey was also interested in research on today's **primates**. He encouraged other well-known scientists in their work, including Jane Goodall and Dian Fossey. These two women studied chimpanzees and gorillas in the wild.

After Louis Leakey died, Mary and her son, Richard, continued working in Africa. Mary Leakey found prehuman fossils more than 3.75 million years old. Richard found an important human skull and other ancient human fossils.

In 1999, Richard's wife, Meave Leakey, led a team of fossil hunters in Kenya. They found a 3.5-million-year-old skull they called Flat-Faced Man.

This fossil was so delicate and so valuable that the team had to clean it very carefully. It took a year to remove the sandstone from the skull, one grain at a time.

All the data isn't in yet and probably won't be for a long time. The discoveries continue.

Fossil hunters keep turning up older and older bones. Scientists think that some of these bones are from much earlier human ancestors.

We now know that these early creatures weren't all alike. Flat-Faced Man might have lived at the same time as Lucy. But they were different from each other.

Paleontologists today believe that there once were lots of different human species on Earth. Most of them became extinct. Others became our own ancestors.

But there's still a lot to learn about how that might have happened.

Sources

Doyle, Sir Arthur Conan. *The Lost World and the Poison Belt*. San Francisco: Chronicle Books, 1989.

Gould, Stephen J. *The Panda's Thumb: More Reflections in Natural History*. New York: W. W. Norton, 1980.

Spencer, Frank. *Piltdown: A Scientific Forgery*. New York: Natural History Museum Publications. Oxford University Press, 1990.

Glossary

amateur relating to a person who is not trained in a field, but is active in the field for a hobby

anatomy scientific study of the structure of plants, animals, or the human body

ancestor direct relative who came before your present family, perhaps from far in the past

ancient very old

anemic relating to a condition in which the blood is lacking enough red blood cells to provide oxygen and nutrients to the body

anthropologist person who studies the science of human beings

evidence something that supports or proves an idea

evolution scientific theory that various types of plants and animals began as other existing types and that differences are the result of changes over long periods of time

exhibit something that is put out for the public to view

extinct no longer living or existing

forge to create a fake object

fossil remains or traces left by prehistoric (see separate entry) living things

genetics scientific study of how characteristics are passed from parents to offspring

genuineness	the quality of being actual and real
geologist	person who studies the science of the origin, history, and makeup of the earth
glacier	huge mass of ice that flows over land
mammal	warm-blooded animals with backbones, including human beings
manor	main house on an estate
mastodon	extinct (see separate entry) animal similar to elephants
microscope	instrument that uses a lens or some other process to magnify objects
missing link	prehistoric (see separate entry) creature that connects human beings with earlier creatures
naturalist	scientist who studies the science of the natural world
paleoanthropologist	person who studies the science of prehistoric (see separate entry) human life
Paleolithic period	period of time in human history from about 2.5 million years ago until about 10,000 years ago; the Old Stone Age
paleontologist	person who studies the science of prehistoric (see separate entry) life of all kinds
plagiarism	act of stealing and passing off the ideas or words of another as one's own
Pleistocene epoch	period of time on Earth from about 1.5 million years ago to about 10,000 years ago.
prehistoric	before written records were made

primate	group of mammals (see separate entry) that includes apes, monkeys, lemurs, and humans
primitive	relating to the early stage of development
retreat	to move back
rubble	relating to waterworn or rough broken stones
site	place or setting of a particular thing
socially	in a manner that is accepted by the majority of people
species	group of similar living things
spiritualist	person who believes that the spirits of the dead communicate with the living
theory	belief based on present information or knowledge

Index

Anderson, Robert B., 55

Clark, Wilfred Le Gros, 43

Darwin, Charles, 35–37

Dawson, Charles, 8–12, 13, 14, 15, 17, 18, 20, 22, 23, 27–28, 30, 32, 33, 40, 45, 46, 47, 48–49, 51, 52–53, 56

Doyle, Sir Arthur Conan, 18–20, 41, 47, 54–55

Early Man in Africa, 42

Flat-Faced Man, 59

Galapagos Islands, 35, 36

Gould, Stephen, 53

Great Ice Age, 23

Harter, Richard, 45

iguanodons, 9

Johanson, Donald, 57–58

Keith, Arthur, 29–31, 40, 49

Leakey, Louis S. B., 39–40, 58–59

Leakey, Mary, 39–40, 58–59

Leakey, Meave, 59

Leakey, Richard, 58–59

Lost World, The, 19–20, 41, 55

Lucy, 57–58, 59

missing link, 36–37

Morris, Harry, 48

Neanderthals, 37

Oakley, Kenneth Page, 40, 43, 52–53

Old Stone Age, 20, 22

Paleolithic period, 22

Peking (Beijing) Man, 38–39

Piltdown Commons, 11

Piltdown II, 33

Pleistocene epoch, 22, 23–25, 30

Slade, Henry, 55

Teilhard de Chardin, Pierre, 14–15, 17, 32, 45, 47, 51–53

Walsh, John Evangelist, 56

Weald, the, 8, 13, 20, 41, 46

Weiner, Joseph S., 42–44, 48–49, 50, 52–53, 56

Woodward, Arthur Smith, 13, 15, 17, 18, 20, 23, 27–28, 30, 31, 32–33, 40, 45, 46, 47, 49, 50–51, 52